Peter Harrison

An introduction to
Vincent
Van Gogh

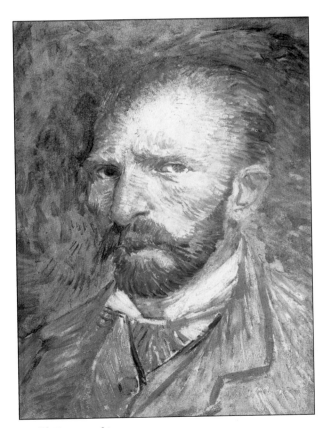

Self-Portrait

HODDER
Wayland

an imprint of Hodder Children's Books

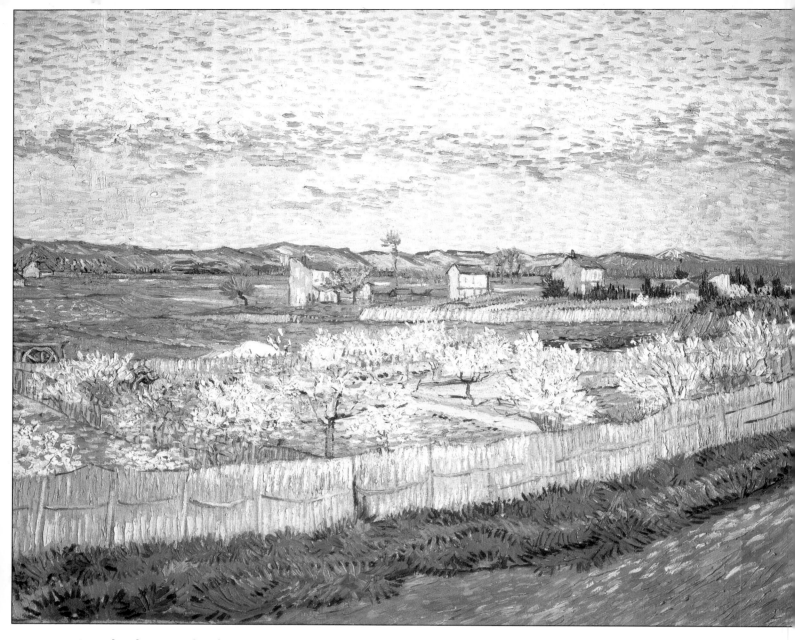

Peach Blossom in the Crau, 1889

Van Gogh painted this beautiful tranquil scene in April 1889, about three months after he had cut off his ear and a few weeks before he moved to the hospital at St Rémy. During this time, he wrote to his brother Theo, '. . . These last three months do seem so strange to me. Sometimes moods of indescribable mental anguish, sometimes moments when the fatality of circumstances seem to be torn apart for an instant.'

Cover: Allée des Alyscamp, Arles

End paper: detail from The Starry Night, 1889

Paintings in this book are identified by their title followed by the artist who painted them. If no artist is named the painting is by van Gogh.

This book was prepared for Macdonald Young Books Ltd by Globe Education of Nantwich, Cheshire

Design concept by M&M Design Partnership

Artwork by Edward Lightfoot

Subject Adviser Professor Arthur Hughes Department of Art, University of Central England, Birmingham

French Adviser Sophie Charpentier

A catalogue record for this book is available from the British Library ISBN 0 7502 3526 8

First published in Great Britain in 1995 by Macdonald Young Books Ltd This edition published in 2001 by Hodder Wayland, an imprint of Hodder Children's Books

© Hodder Wayland 1995

Printed and bound in Hong Kong

Acknowledgements
Collection: State Museum Kröller-Müller, Otterlo, the Netherlands: 13b
Collection Vincent Van Gogh/Van Gogh Museum, Amsterdam: 6l, 6c, 6r, 8, 11, 12, 13t, 17b, 28b
Bridgeman Art Library, London: cover, Christies, London; end paper and 27t, Museum of Modern Art New York; 3 Rijksmuseum Kröller-Müller, Otterlo; 4, Courtauld Institute Galleries, Univ. of London; 9 Guildhall Library, Corporation of London; 10, Louvre, Paris/Giraudon; 14t, Christies, London; 14b, Kunsthause, Zurich; 15; 16b Musée d'Orsay, Paris/Giraudon; 17tl, National Gallery, London; 17tr, Art Institute of Chicago; 18t, Tate Gallery, London; 18b, Musée d'Orsay, Paris/Giraudon; 19t Musée d'Orsay, Paris/Giraudon; 19b Pushkin Museum, Moscow; 21t Rijksmuseum Kröller-Müller, Otterlo; 21b Pushkin Museum, Moscow; 22 Museum of Modern Art, New York; 23t Musée d'Orsay, Paris/Giraudon; 24l Courtauld Institute Galleries, Univ. of London; 24r Private Collection; 25 Oskar Reinhart Collection, Winterthur, Switzerland; 26 Musée d'Orsay, Paris/Lauros-Giraudon; 27b Musée d'Orsay, Paris/Giraudon; 28t Musée d'Orsay, Paris/Giraudon; 29 Musée d'Orsay, Paris/Giraudon
Life File: 7 (Emma Lee); 20t (Emma Lee)
Tony Stone: 16t

759.949 Coc

ART FOR YOUNG PEOPLE

Vincent
Van Gogh

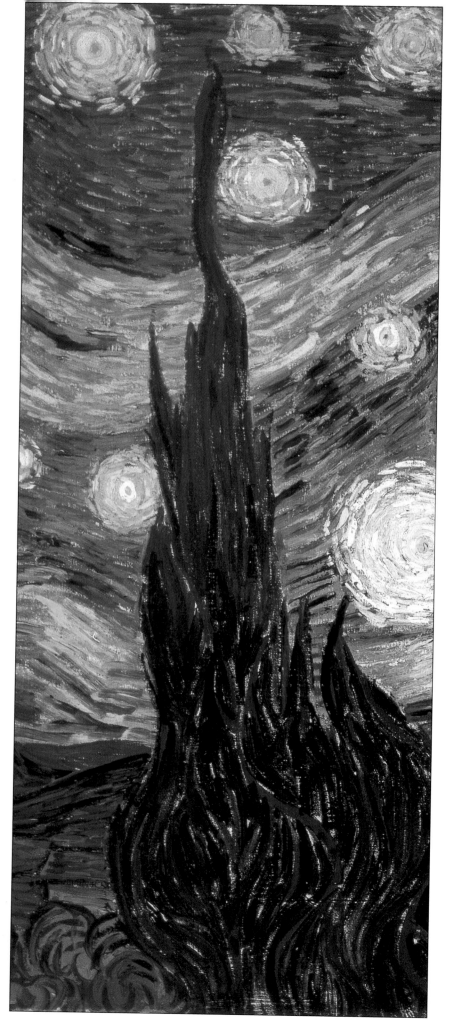

Important events in the life of

Vincent Van Gogh

1853 Vincent is born at Groot Zundert in Holland on 30 March.

1869 He starts working as a clerk at Goupil Art Gallery in The Hague.

1873 He is transferred to London and becomes fluent in English.

1874 Transferred to Paris.

1876 Dismissed from Goupil's, he takes a job as a teacher in Ramsgate, England, and then as an assistant to a Methodist minister at Isleworth which is now part of London.

1877 Returns to Holland to study theology.

1880 Decides to become an artist.

1881 Becomes obsessed with his cousin Kee Vos-Stricker and later Christien Hoornik.

1883 Lives with his parents at Nuenen near Eindhoven drawing and painting country life.

1886 Moves to Paris and lives with his brother Theo. Meets Pissarro, Bernard, Lautrec and Gauguin.

1888 Moves to Arles in south of France and devotes himself to painting. Gauguin joins him but they later quarrel. Vincent cuts off his ear and Gauguin leaves. Vincent enters hospital suffering from delusions.

1889 Vincent enters the asylum in St Rèmy and continues to paint.

1890 He moves to Auvers-sur-Oise, a village north of Paris and shoots himself fatally two months later.

Contents

Those first days

Vincent van Gogh was the eldest of six children. His parents married in 1851 and within a year his mother gave birth to a stillborn child. Exactly one year later, on 30 March 1853, Vincent was born and was given the same name as his dead brother.

The family lived in a small house in the village of Groot Zundert which was in the Netherlands near to the border with Belgium.

The village was far away from busy towns and cities. The local people lived by farming and their lives were dominated by the seasons and the work of the farming year.

Vincent's father, Theodorus van Gogh, the pastor of the local church did not have a great deal of money to support his growing family. He was kind and very religious but could not understand his eldest child, Vincent.

Theodorus van Gogh
Vincent's father

Vincent van Gogh
aged 13 years

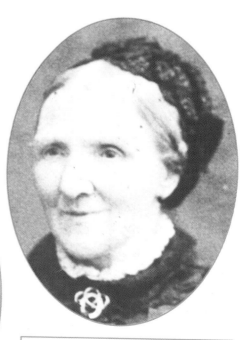

Anna Cornelius van Gogh
Vincent's mother

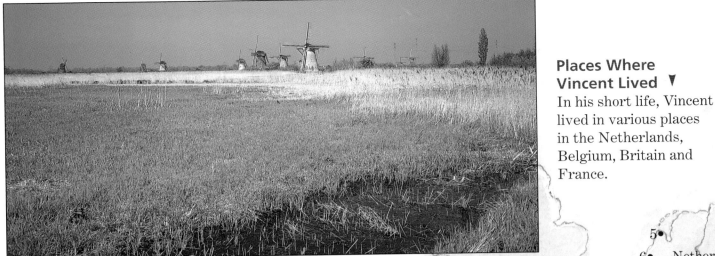

The part of the Netherlands where Vincent grew up was a land of peat bogs and heather. Later he moved around quite frequently, living part of the time in remote country areas.

Places Where Vincent Lived ▼

In his short life, Vincent lived in various places in the Netherlands, Belgium, Britain and France.

Key

1. Zundert	6. The Hague
2. London	7. Brussels
3. Ramsgate	8. Paris
4. Etten	9. Arles
5. Amsterdam	

Vincent lived in Groot Zundert until he was 11 years old. He went to the local school but was a solitary boy who spent much of his time wandering around the countryside. Vincent's parents were concerned about him. They sent him to two different boarding schools but he didn't do well at either of them.

When he left school his mother's brother found him a job in the Goupil Gallery which sold pictures. The gallery was in The Hague – the capital city of the Netherlands. Vincent worked there for three years surrounded by pictures for the first time in his life.

Vincent's Birthplace ▼

Vincent often thought and talked about the house in Groot Zundert where he was born.

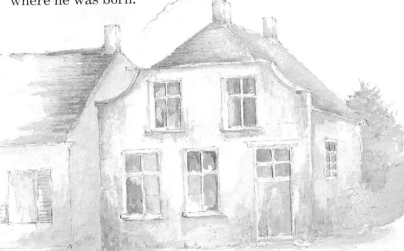

'My dear Theo'

Theo van Gogh

Vincent worked well at Goupil's gallery. He tried hard, was polite and always arrived in time for work. His employers were pleased with him and sent him first to their branch in Brussels, Belgium, and then to London.

On arrival in London, Vincent found a room to rent and walked every day to his work in the city. At first, things seemed to go well. He wrote home to his family telling them about London and he seemed happy and settled.

Vincent was very close to his younger brother, Theo. He wrote to him frequently and was to rely on him for help and advice throughout his troubled life.

The Goupil Gallery
The gallery where both Vincent and Theo worked was furnished like a sitting room in someone's house. There were curtains and rich wallpaper and chairs for clients to sit in.

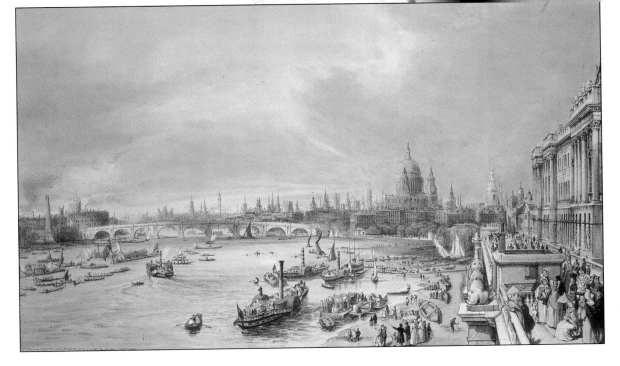

Somerset House and the Thames, London, Parrott, 1840 ▶
London was expanding enormously while Vincent lived there. He was fascinated and horrified by the large numbers of homeless, starving people who wandered the streets, searching for work and somewhere to live.

In London, Vincent soon became moody and depressed. His sister went to live with him for a short while, but this did not help. Vincent lost interest in his work and was moved to the Paris branch. Finally, he quarrelled with the owners of the gallery and was told to leave.

Not sure what to do next, he took a job in England as an unpaid helper at a small school in Ramsgate. (Theo had suggested he should become a painter.)

Becoming more and more concerned with religion, Vincent moved to Isleworth near London as assistant to the Methodist minister. Letters to Theo tell of the happiness he experienced preaching in church. '. . . I felt like somebody who, emerging from a dark cave underground, comes back to the friendly daylight . . .'

Letters to Theo
While in England, Vincent began to write regulary to Theo. He often drew pictures in the margins of his letters to show things he had seen.

9

Something comforting

▲ Zundert church
The church where Vincent's father was pastor when Vincent was a young boy.

In 1877, Vincent returned to the Netherlands and tried to train as a preacher. He was told he must study the Latin, Greek and Hebrew languages but he was too impatient. He spent his time reading the Christian Bible and was in a constant state of religious excitement. By January 1879, he was preaching in the Borinage, a mining district in Belgium. Here he tried to live in complete poverty like the local people. By the middle of 1880, he was exhausted. Dressed in dirty, ragged clothes, he was eating next to nothing having given away what little money had been sent by his family.

Supper at Emmaus, Rembrandt, 1648 ►
Rembrandt was a great 17th century Dutch artist. In this picture, he showed a vision of Christ appearing to two of the disciples. For Vincent, this was one of the greatest religious paintings ever created.

Rembrandt makes you feel part of the group of figures around the table. Christ, in the middle, seems to be glowing with a light that reflects off the people and the tablecloth. The looks on the faces of the people tell us they are both astonished and pleased to see this vision.

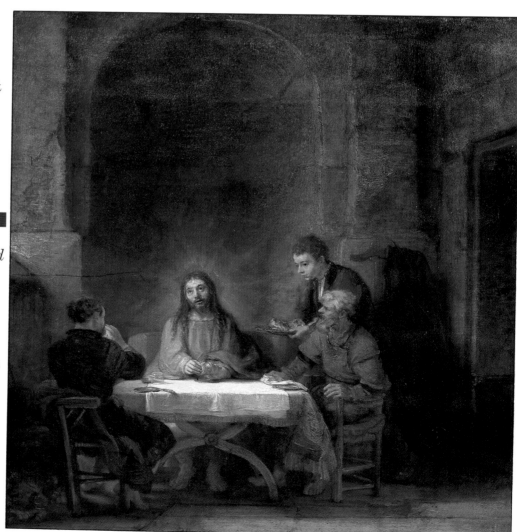

Still Life with Bible, 1885 ➤

After he had decided to become an artist, Vincent painted this still life. He had spent years copying hundreds of passages from the Bible.

Vincent makes you ■ *understand just how important the Bible is to him. You cannot read the words but the strong light and the dark shadows give a feeling of hours spent reading by candlelight.*

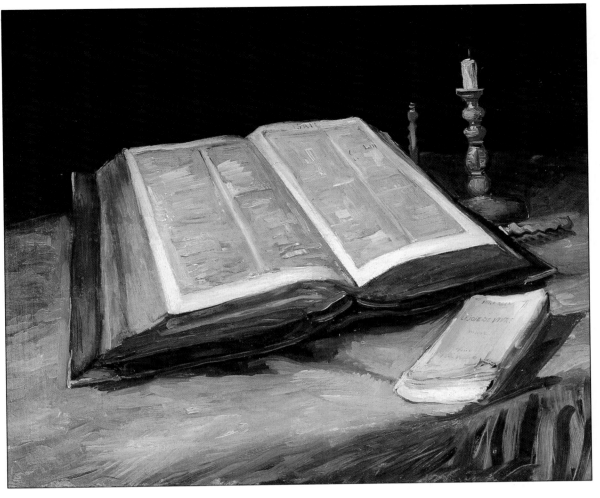

But Vincent had been drawing the people and houses of Borinage. By the time he moved back to Brussels that October, he was thinking less about religion and more about famous artists such as another great Dutch painter, Rembrandt. Finally he decided to become a painter.

His parents were now living in Etten and van Gogh went to stay there. He spent his time drawing local people and landscapes and experimenting with water-colour techniques.

Poverty in the 19th Century
Those people that had jobs in the mines or the new factories worked for long hours and suffered great hardship. Many were injured or killed in accidents.

Difficult relationships

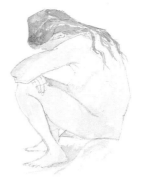

Vincent always found it hard to form lasting relationships with other people, especially with women. He was 28 years old when he met his cousin Kee Vos-Stricker at his parents house in Etten. Her husband had recently died and Vincent fell in love with her. She returned to Amsterdam in fright and refused to see him ever again.

After quarrelling with his father, Vincent moved to The Hague which is the capital city of the Netherlands. Living on money supplied by Theo, he took a room and started to work on his drawing.

Shortly afterwards, he met a woman called Christien Hoornik, whom he called Sien. Vincent visited her often and she began to pose for his drawings. She was very poor and had children she could not look after very well. Before long, Vincent set up house with her, distressing his father and worrying Theo. After a time, he realised that Sien would never change and reluctantly decided he must leave her. This was the closest Vincent ever came to having a family of his own.

Meanwhile, his artistic talent was developing fast. He did some beautiful drawings of the town, the surrounding countryside and the coast. He also started painting in oils.

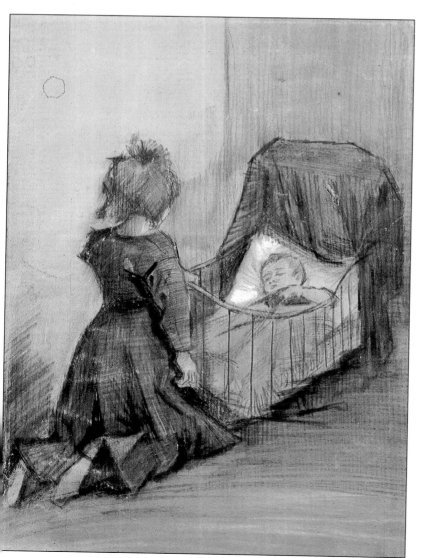

◄ **Girl kneeling in front of Cradle**
Vincent made this drawing of two of Sien's children while they all lived together.

Kee Vos-Stricker

At first Kee and Vincent were very friendly but when Vincent told Kee that he had fallen in love with her, she had to explain that she didn't love him in return. Vincent could not accept this, so Kee quickly returned to her parent's house in Amsterdam. Vincent chased after her using money given to him by Theo but was prevented from ever seeing her again.

After this rejection Vincent said 'I get on much better with my work.'

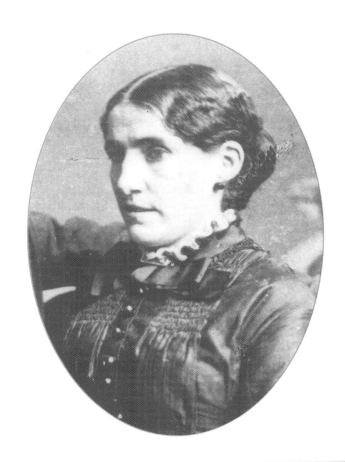

Sien sitting on the Ground, 1882 ►

For a while Vincent was very happy. He had a family which he felt was his own. In the end, however, Sien told Vincent that she did not want him to look after her and her children, which hurt him very much. They quarrelled and finally agreed to part. Vincent never tried again to make a family of his own.

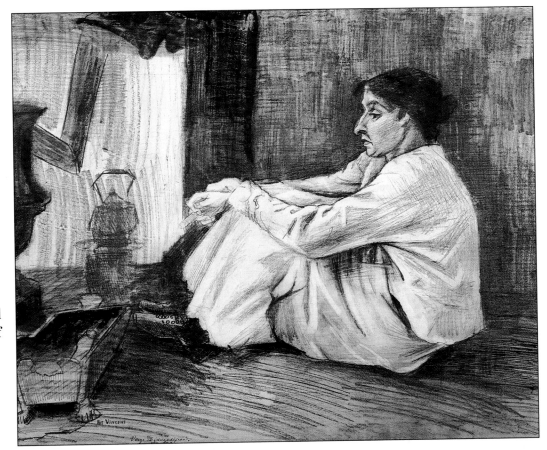

Lives without rest

In 19th century Europe, there were very few laws to protect working people. Employers could force men, women and children to work long hours for little pay. In his early years as a painter, Vincent lived often in country districts of the Netherlands. In these areas, people lived in small communities, trying to scratch a living from what they could grow in the fields. Vincent drew and painted the working lives of these people. He showed how their bodies were stunted and twisted by the hard lives that they led.

▲ **In the Orchard, 1883**
Vincent loved to draw trees and people who worked at planting and harvesting things which grew in the earth.

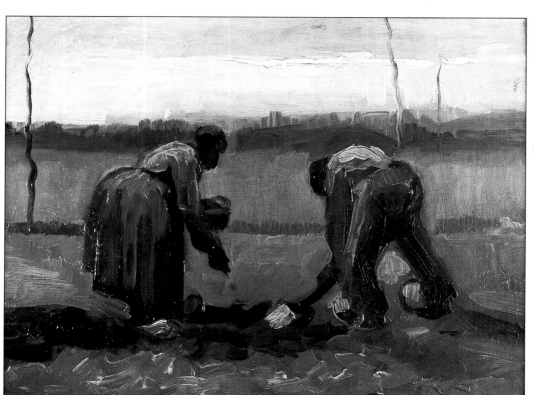

◄ **Two Peasants working in a Field**
At this time, Vincent concentrated on learning to draw accurately, but he did try painting. In this picture, he used oil paints.

■ *Vincent used thick paint to show the shape of the people and the earth. Patches of white show up the backs of the people and the ridges of the earth.*

The Potato Eaters, 1885 ►

This painting shows a family, huddled around a single lamp, eating their one meal of the day: a plate of potatoes.

The dull, dark colours of this picture are like the hard, dull lives of the people sitting at the table. Light from the lamp falls on their work worn hands, tired faces and simple meal. You feel drawn into their world.

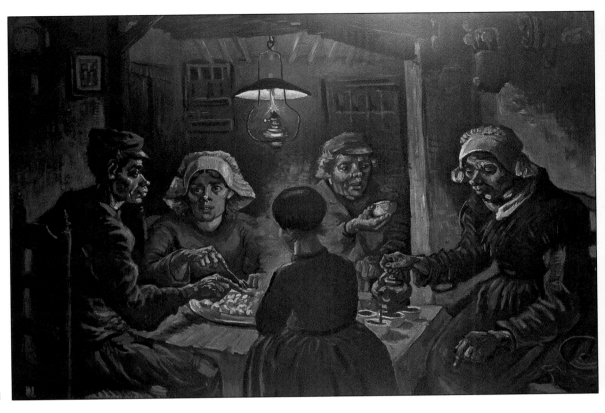

All through his adult life, Vincent worked enormously hard. Once he had decided to become a painter, he usually worked ten and twelve hours a day. He ate very little and often did not get enough sleep. He thought a great deal about people whose lives were difficult, such as labourers who worked in the fields all day with very little food or rest.

Writing to Theo from the country, he commented about his work '. . . those people, eating their potatoes in the lamplight, have dug the earth with those very hands they put in the dish, . . . they have honestly earned their food.'

Without Theo's help and constant support, Vincent could not have managed. Theo worked in the Goupil Gallery in Paris and because he understood pictures, was able to discuss painting with Vincent. These discussions gave Vincent the strength to try out his ideas.

Theo also sent Vincent enough money to live on and bought paint and canvasses for him. Theo believed deeply in his brother's talent and went to great lengths to help him develop it. He also tried to sell Vincent's paintings in the gallery and arranged for Vincent to have his paintings included in exhibitions.

Impressions of Paris

Vincent's decision to become a painter happened at a time when great changes were taking place in the kinds of paintings produced by artists in France. Artists such as Manet, Monet and Pissarro were painting landscapes and views of everyday life that were quite different to traditional paintings. The subjects chosen were different and so was the method of putting the paint on the canvas.

People thought these pictures looked like hurried glances at the subjects and they laughed at them, calling them Impressionist paintings.

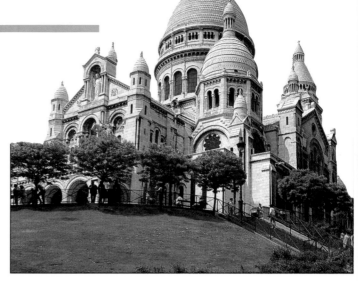

▲ **Montmartre**
Vincent lived in a part of Paris known as Montmartre where there is a huge church on top of a hill.

The Impressionist painters needed to sell their paintings but this was not easy. They formed a group and put on exhibitions together sharing the costs.

Vincent went to live with Theo in Paris in March 1886 and stayed for almost two years. The two brothers lived in an apartment in Montmartre and Vincent enrolled at the Corman Studio to study painting but only stayed three or four months. Theo knew the Impressionists because of his job at the gallery, liked their work and was able to introduce Vincent to them.

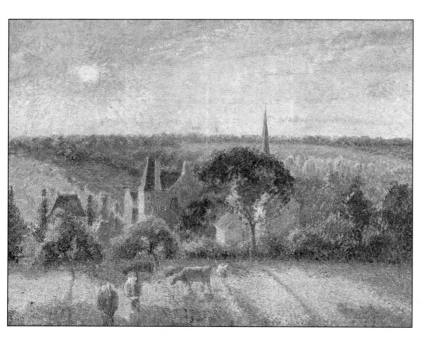

◄ **Countryside near Eragny, Pissarro, 1895**
Pissarro was one of the most important of the Impressionist painters. This painting shows the village where he lived from 1884.

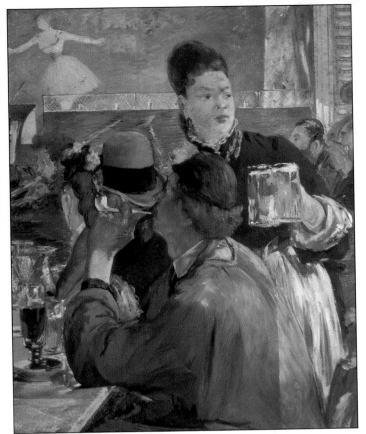

▲ The Waitress, Manet, 1878

The Impressionist painters often met together in
Paris cafés to relax and talk about their work.
In this painting, Manet gives us a view of café life.
The man wearing the blue smock is an artist.

Sunday Afternoon on the Isle of the Grande Jatte, Seurat, 1886 ▼

Seurat was working in Paris at the time that van
Gogh was there. Seurat liked painting in the open air
like the Impressionists but his work was more
exact. He had a way of putting small touches of
different colours on to the canvas next to each
other. This way of painting is known as pointillism.

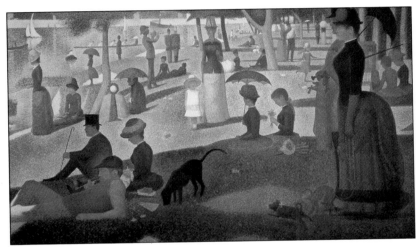

Kingfisher, 1886 ►

Vincent painted this
picture soon after he had
arrived in Paris. He is no
longer using dull, dark
colours. This picture is
alive with sunlight which
reflects off the river and
the kingfisher's back.

*In this picture
Vincent used thick oil
paint and strong
brush strokes. This is
a way of painting that
is known as impasto
and it is very typical
of Vincent's work.*

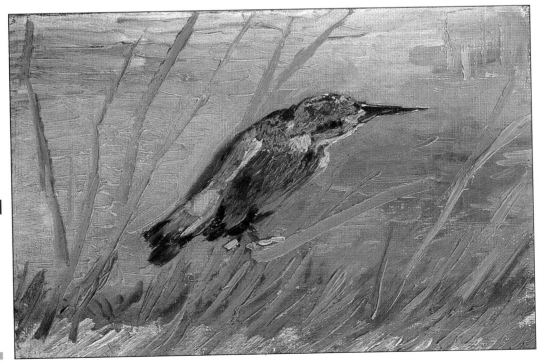

Shelter for comrades

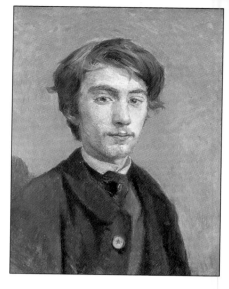

Vincent was very interested in the Impressionists. He visited them as often as he could and liked seeing their paintings. He especially liked the way they formed themselves into a group to put on exhibitions. He called the artists he met in Paris 'comrades' and he wanted to create a small community where they could all work together and help each other.

▲ **Emile Bernard, Toulouse-Lautrec, 1885**
Vincent met Emile Bernard at the Cormon Studio and they became close friends. Vincent often visited Bernard's family.

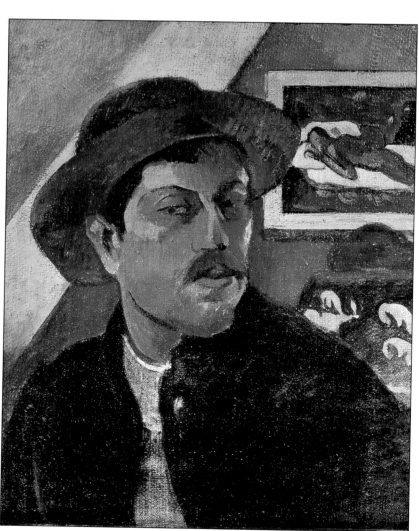

Although Theo supported his brother and believed in his talent, he was not so happy to be living with him. Vincent was very excitable and argued with everyone. He would stay out late arguing with other artists such as Paul Gauguin, Emile Bernard, Toulouse-Lautrec and anyone else. Then he would either return home alone, get depressed and argue with Theo, or he would bring his friends back to the flat and argue with them there.

Theo was finding it almost impossible to get any rest after his hard day's work in the gallery.

◄ **Self-Portrait, Gauguin, 1893**
Paul Gauguin was in Paris learning about painting from the Impressionists at the same time as Vincent. They spent many hours talking about art.

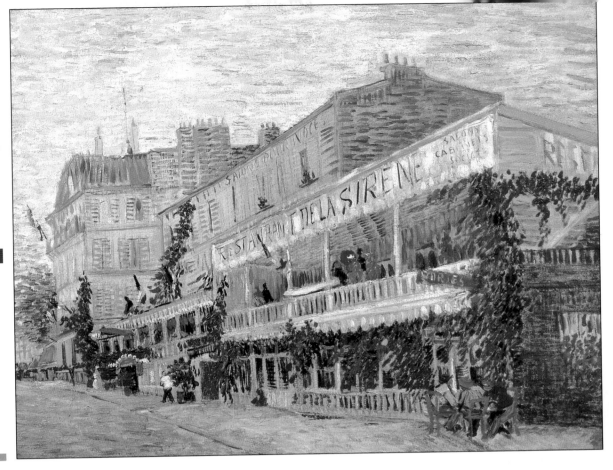

Restaurant at Asnières, 1887 ▶
Vincent painted this picture on one of his visits to Bernard's family home in the town of Asnières.

For this picture, Vincent used a style that is very similar to that used by the Impressionists. The colours are light and bright, with many small touches of colour which create a feeling of movement and life.

Despite the arguing, the late nights and the lack of sleep, Vincent's ability as a painter expanded by leaps and bounds. He was painting with oil paints in a wide range of styles.

He experimented with Impressionism and developed techniques of his own. Although he exhibited his pictures in cafés and shops he is not known to have sold any of them.

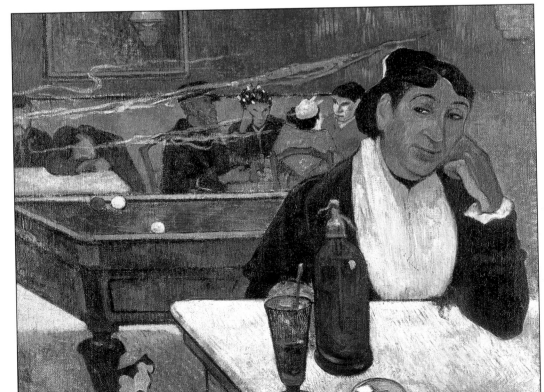

◀ Night Café at Arles, Gauguin, 1888
Like van Gogh, Paul Gaugin was a lonely man desperately looking for friendship. He visited van Gogh in Arles in the south of France about two years before he went to live on Tahiti, an island in the South Pacific. When he left France it was to find a simpler way of life where he would be allowed to paint as he pleased.

19

In the sunshine

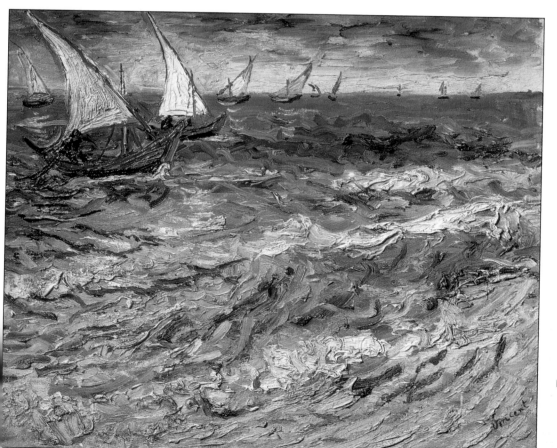

▲ The centre of Arles

Arles is a small town in the country which was wonderful for Vincent after living in a small flat in Paris for two years. Even the people looked different. They were dark-haired and sun-tanned and they spoke French in a different way. But above all, it was warm and sunny as you can see from this modern photograph of the centre of Arles.

E ventually Vincent became more and more dispirited and anxious in Paris. His quarrelling meant he could not keep friends and soon he didn't have any people to talk to.

One day he decided to move to Arles, a small town in southern France. As with many of Vincent's decisions, it is not clear why he decided to go there rather than anywhere else. It might be that Toulouse-Lautrec had told him about his home town of Albi which was also in the south.

◄ The Boats At Sainte-Marie, 1888

Once Vincent had moved to Arles, he went on short trips to visit the surrounding country. He found a small fishing village called Sainte-Marie on the shores of the Mediterranean Sea and painted several pictures of the boats there.

■ *Thick layers of paint show how the waves are breaking at their tops. Sunlight reflects off the waves and the sails of the boats. We know it is a bright blowy day.*

The journey was very long. It took 16 hours by train to reach Arles. Vincent arrived there one morning in February 1888 convinced that his life was going to change for the better and that all his difficulties would disappear in the warm sunshine.

When the train stopped in Arles, it was snowing. This, however, did not dampen his spirits. He spent the next few months getting used to this new place. Everything was so different to the life he had lived before.

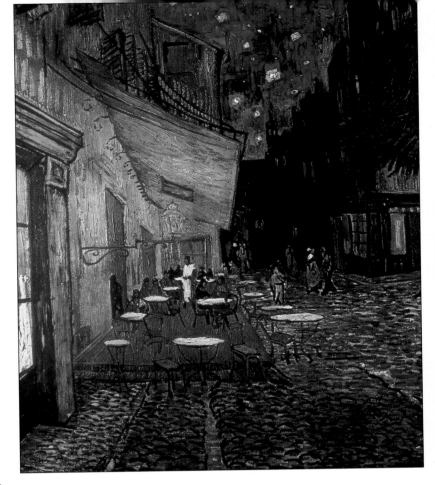

Café Terrace at Night, 1888 ➤

Vincent put to use the techniques he had learnt from the Impressionists in Paris. He worked quickly in the open air with thick paint and small brush strokes. Sometimes he painted for 16 hours without stopping. So that he could paint this scene at night, he stuck candles around his broad-brimmed hat, much to the amazement of the local people of Arles.

■ *Small dashes of colour contrast the warmth and light of the café with the darkness of the surrounding street. The cobblestones glisten with reflected light. Like a passer-by, you are drawn towards the café tables. In the dark sky above, the stars are twinkling.*

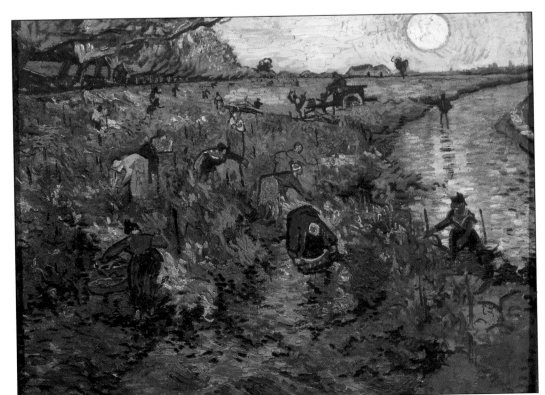

◄ Red Vineyards at Arles, 1888

By the autumn Vincent was painting the rich colours of the countryside around Arles showing the local people collecting in the harvest.

21

The Yellow House

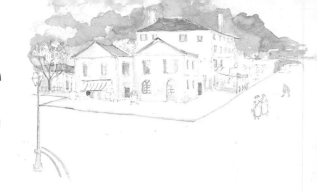

Vincent was filled with enthusiasm. He was back in the countryside, where he loved to be, surrounded by fields and farms. The light was quite unlike any he had ever seen before. It was much, much brighter. The shadows were very dark but colour was everywhere, lit up by the light of the sun. He set to work immediately and wrote to Theo begging large amounts of white and yellow paint.

For the first few months he rented a room in an hotel but he quarrelled with the landlord who tried to tell him he should pay more money than they had first agreed.

Then, Vincent found a small house in the town where he was able to rent rooms. It was painted yellow on the outside, and so he always called it The Yellow House. Once he had moved in there, he became very preoccupied about Paul Gauguin, one of the artists whom he had met in Paris. He wrote constantly to Gauguin and Theo, saying he wanted Gauguin to come and stay with him in Arles. '. . . If Gauguin were willing to join me, I think it would be a step forward for us.'

And all the time he was drawing and painting: the orchards in blossom, the people, the scenes in and around the town.

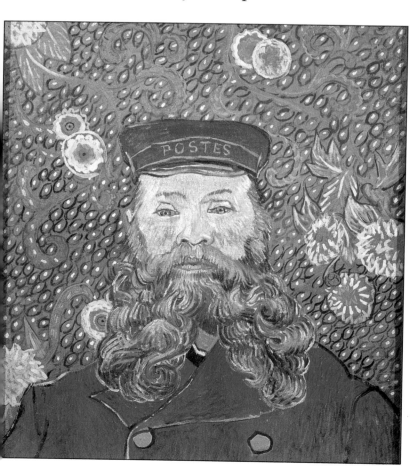

◄ **Postman Roulin, 1888**
One of the few people Vincent made friends with in Arles was the postman whose family name was Roulin. Vincent painted him several times in his postman's uniform. He also painted other members of Roulin's family.

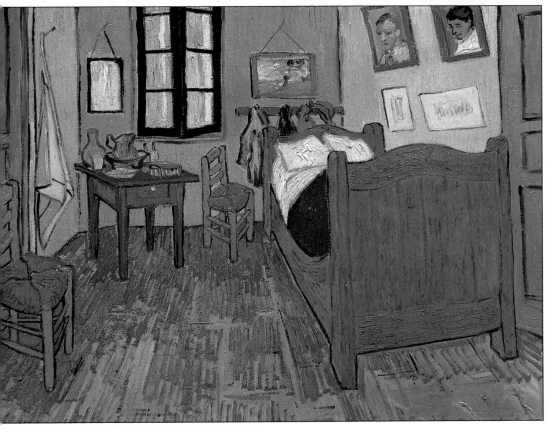

■ *There is something slightly odd about this room. The pictures over the bed hang on the wall at strange angles and the lines of the floorboards and the bed seem to rush away into the distance. There is a feeling that the room is waiting for something to happen.*

▲ The Bedroom at Arles, 1888

Vincent's bedroom in The Yellow House was very important to him – he painted it three times. The furniture was strong and simple; the colours bright; everything was neat and tidy.

Sunflowers, 1888 ►

The colour yellow became especially important to Vincent while he was living in Arles. Sunflowers interested him a great deal because of their strong yellow colour. In total he painted 10 different pictures of sunflowers. Today, these pictures are probably the best known of all his paintings.

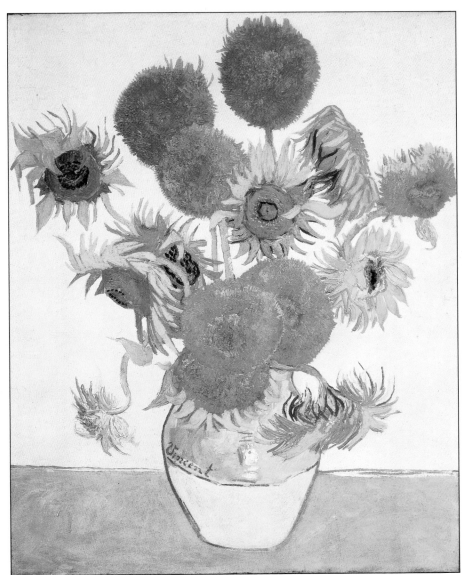

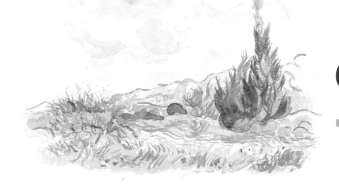

Grave difficulties

Gauguin arrived in Arles in the autumn and for two whole months he and Vincent got on well enough together. But then they began to argue. Finally, after a very bad row, Vincent cut off the lower part of his left ear.

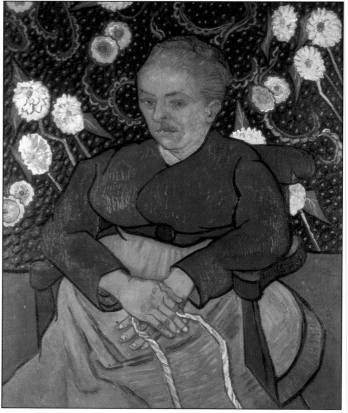

▲ **Augustine Roulin, 1889**
Vincent painted postman Roulin's wife in the spring of 1889. Roulin's job was moved to another town. This added to Vincent's unhappiness because Roulin was one of his few friends. This portrait is known as La Berceuse – Vincent painted two versions of it.

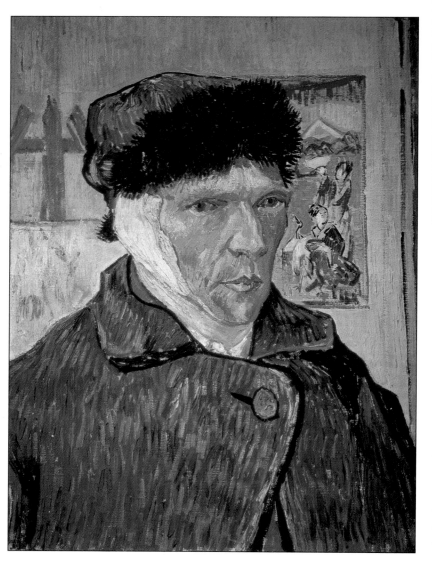

◄ **Self-Portrait with a Bandaged Ear, 1889**
Vincent recovered enough from his injuries to complete this and a second self-portrait while his wound was still covered by a bandage. He looks very pinched and ill in this picture, but he was still busy painting.

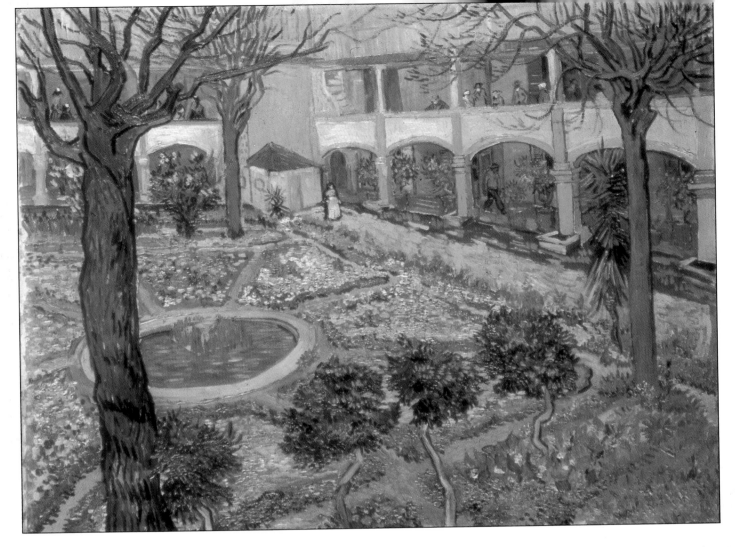

▲ The Hospital Garden at Arles, 1889
Even in hospital, Vincent carried on painting whatever was around him. He said that he only felt well when he was painting.

Vincent quickly became very ill and was clearly in a very unhappy mental state. On Christmas Eve he was taken to hospital, Gauguin sent for Theo and left Arles for ever.

In a small town like Arles, the incident created a lot of interest. Some of Vincent's neighbours said he was a lunatic and should be locked up. After 10 days Vincent was able to leave hospital. He returned to The Yellow House and managed to carry on painting. He was short of money and almost totally alone.

After a month he was back in hospital again hearing voices and convinced he was being poisoned. In May he moved to a special hospital in St Rémy.

Vincent lived in Arles for 444 days – just over a year. In that time, he painted nearly 200 pictures, made over a 100 drawings and wrote about 200 letters. Even for a healthy person, this would be a huge amount of work.

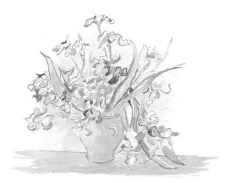

Fighting his illness

At the hospital in St Rémy Vincent was given two rooms – one where he could sleep and one where he could work. To begin with he was unwilling to leave the hospital or its garden and was happy painting the view from the window.

When he was well, he produced wonderful pictures out of his imagination. But he suffered regular bouts of illness. While he was ill he was likely to swallow paints and paraffin oil and the doctors had to keep a careful eye on him.

During this time, Theo had married and his wife, Johanna, gave birth to a baby boy on 31 January 1890. The child was named Vincent Willem after his uncle. Vincent painted branches of almond blossom and sent them to Paris for his namesake's nursery.

Soon afterwards he was allowed to make a trip to Arles but failed to return on time. An attendant from the hospital found him wandering, not knowing what he was doing. This was followed by a long period of illness.

When Vincent was well again he asked Theo to move him nearer to Paris. The painter, Pissarro, kindly arranged for Vincent to stay at Auvers-sur-Oise.

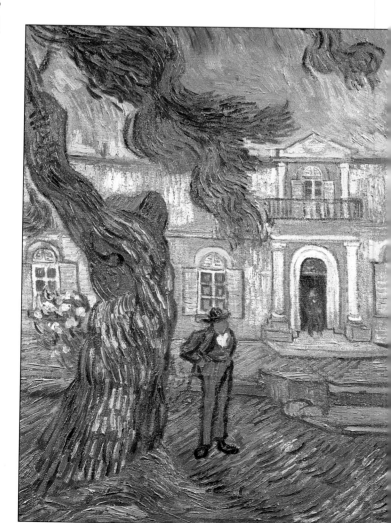

Hospital at St Rémy, 1889 ►
The doctors who cared for Vincent were kindly people. They allowed him to paint in the grounds and he produced many pictures of the flowers and trees in the gardens. In a letter to Theo he wrote, '. . . more than ever, I am in a dumb fury of work.'

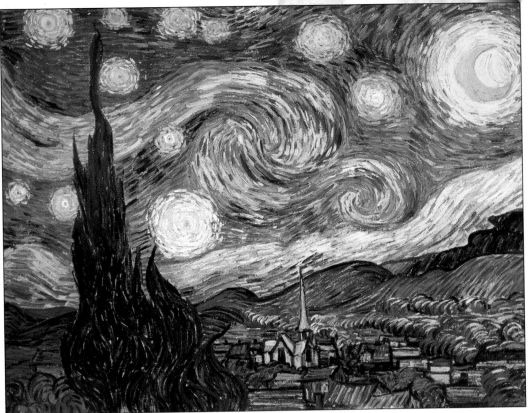

On 16 May, Vincent left the hospital having produced 11 pictures in his last fortnight there. He took the train to Paris and stayed three days with Theo and his wife. He was cheerful, enjoyed seeing his nephew and godson and inspected the hundreds of his paintings that were stored in the apartment.

The noise of Paris upset him and he became anxious to move on to a quiet place where he could work.

This painting shows very clearly how Vincent's way of putting paint on the canvas was changing. The straight brush strokes have turned to waves and swirls. His face has become like a mask. The paint is still very thick but he has found a way of giving it great detail.

Self-Portrait, 1889 ▼
This is one of the last self-portraits that Vincent ever made. It was painted after a particularly bad bout of illness during which he was too afraid even to leave his room.

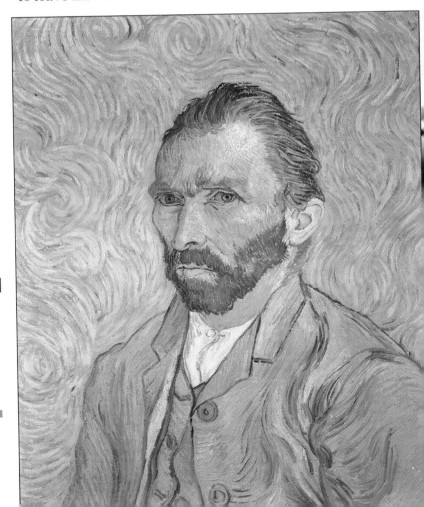

The final weeks

V incent was met off the train at Auvers-sur-Oise by Dr Gachet. Dr Gachet was friendly with many painters and had promised Pissarro that he would keep an eye on Vincent.

Vincent took a room in a café that was only five minutes walk from Dr Gachet's house. Sometimes he was very depressed and could not see a future for himself but at other times worked as well as ever. When Theo and Johanna visited, Vincent took great pleasure in showing his nephew the animals in the nearby farmyard.

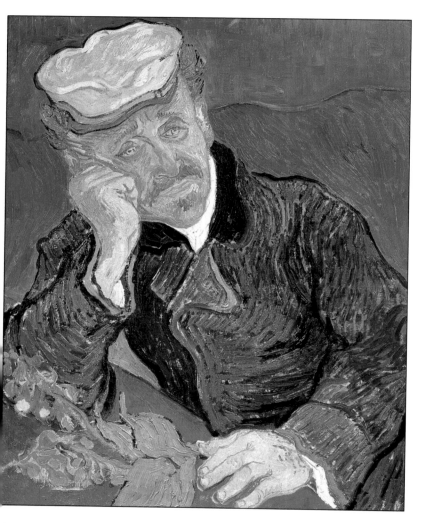

◄ **Dr Gachet, 1890**
Within a month of living in Auvers, Vincent had painted the doctor's portrait.

Daubigny's Garden, 1890 ▼
One of the last letters that Vincent sent to Theo contained this drawing of the garden created by the painter, Daubigny.

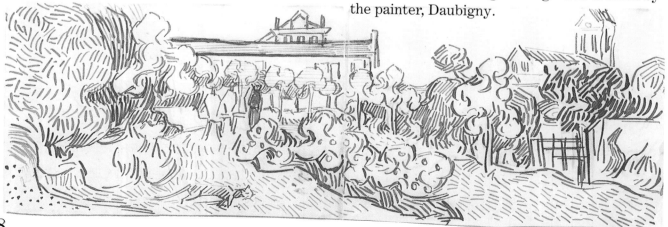

The Church at Auvers, 1890 ➤
Vincent painted the village church at Auvers about a month before he died. It is a very bold and stunning picture.

Vincent uses dashes 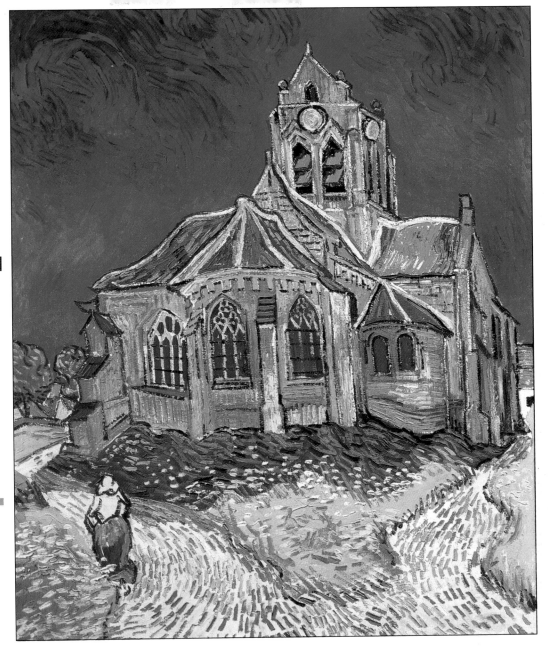 of paint on the path at the front of the picture to lead you to the church and the figure of a woman to give the picture scale. The strong, contrasting colours, the powerful lines and the swirling shapes around give this picture an extraordinary quality.

He worked endlessly at Auvers painting one picture for every day that he was there. He also made a number of drawings. In July, he became very depressed and quarrelled with Dr Gachet over the framing of a picture. A letter he sent to Theo could not be understood and Theo worried for his brother's peace of mind. On 27 July, he had dinner at the Gachets but left suddenly.

Later, the cafe owner found him in bed with a gunshot wound in his chest. Theo rushed from Paris but Vincent died early on 29 July 1890. Theo died just six months later.

In 1973, Theo's son Vincent van Gogh opened the Rijksmuseum van Gogh in Amsterdam: a monument to the work of one of the most well-known artists of the last century.

More information

Glossary

canvas Woven cloth on which artists make their oil paintings. The cloth must first be sealed with a coating known as a ground and stretched on a frame.

Corman Studio In the 19th century young artists would enrol at the studio of a well-known painter. Ferdinand Cormon was a popular teacher. His pupils included Toulouse-Lautrec and van Gogh.

impasto
A way of putting thick paint on to a surface so that the marks of the brush can still be seen. It can be used with oil paint but not with water-colour. Important artists who used impasto include Rembrandt and van Gogh.

Impressionism A style of painting that developed in France around 1860 which tried to show an immediate visual impression of a scene. It involved new techniques and new choices of subjects. Many people were shocked but it has become one of the most important changes in art of the 19th and 20th centuries.

Impressionists The first Impressionist artists were Monet, Renoir, Sisley and Bazille. They soon included Pissarro, Cézanne, Morisot and Guillaumin, and later Degas and Manet. There were eight exhibitions of their work between 1874 and 1886.

Independent Exhibition The annual exhibition held by the Society of Independent Artists founded in 1884.

Montmartre In the 19th century Montmartre was a village near to Paris that was a favourite with artists. Today it is a well-known artistic district of the capital city.

oil paint The most usual painting material used by European artists since 16th century. It consists of coloured substances called pigments mixed with oil. The oil is usually linseed or walnut oil.

pastor The minister in charge of a church.

pointillism A technique using small touches of pure colour so that when seen from a distance they react together visually to give a vibrant effect.

talent A special or very great ability in a particular area such as a talent for music or tennis.

water-colour Paint that can be thinned with water.

People

Emile Bernard (1868-1941) French painter and writer. He organized the first exhibition of van Gogh's work after his death in 1890.

Charles-François Daubigny (1817-78) French landscape painter, one of the first painters to work in the open-air.

Paul Gauguin (1848-1903) French painter who studied for a while with the Impressionists but later developed his own style. He has had a great influence on the development of 20th century art.

Edouard Manet (1832-83) French painter and graphic artist. He is seen as one of the founders of modern art.

Claude Monet (1840-1926) French Impressionist painter. Honoured in his long lifetime, his work today is even more popular than ever.

Camille Pissarro (1830-1903) French Impressionist painter and graphic artist. A gifted teacher.

Georges Seurat (1859-1891) French painter who developed Pointillism as a technique.

Henri de Toulouse-Lautrec (1864-1901) French painter and graphic artist. He is best known for his prints and posters.

Index